# CHOCOBO and the AIRSHIP
## A FINAL FANTASY PICTURE BOOK

STORY BY **KAZUHIKO AOKI**
(Square Enix)

ART BY **TOSHIYUKI ITAHANA**
(Square Enix)

# KABOOM!

Chocobo watched as a brilliant firework lit up the sky.

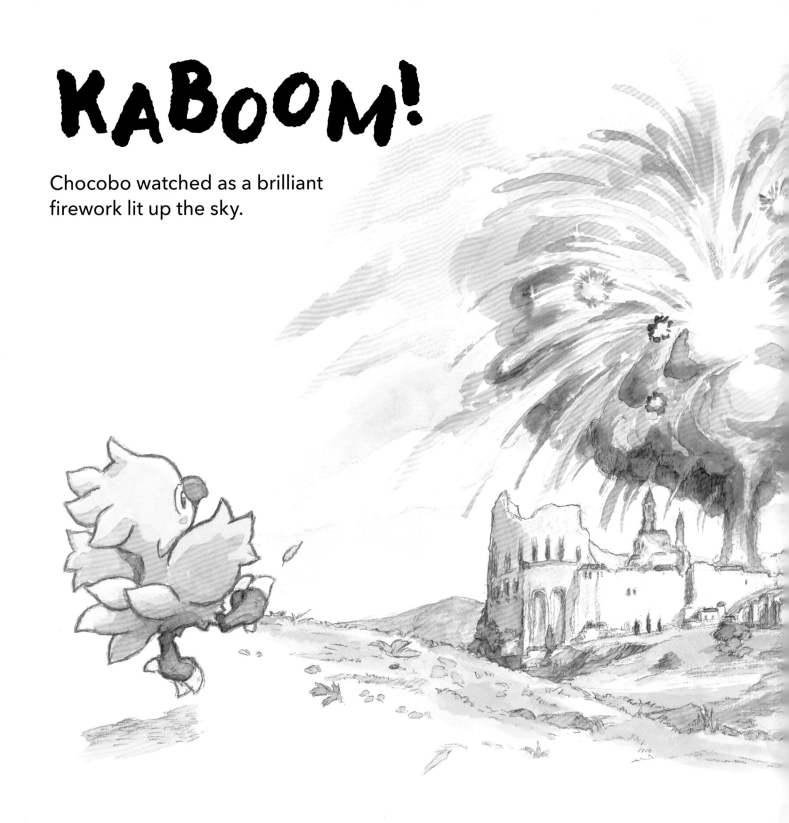

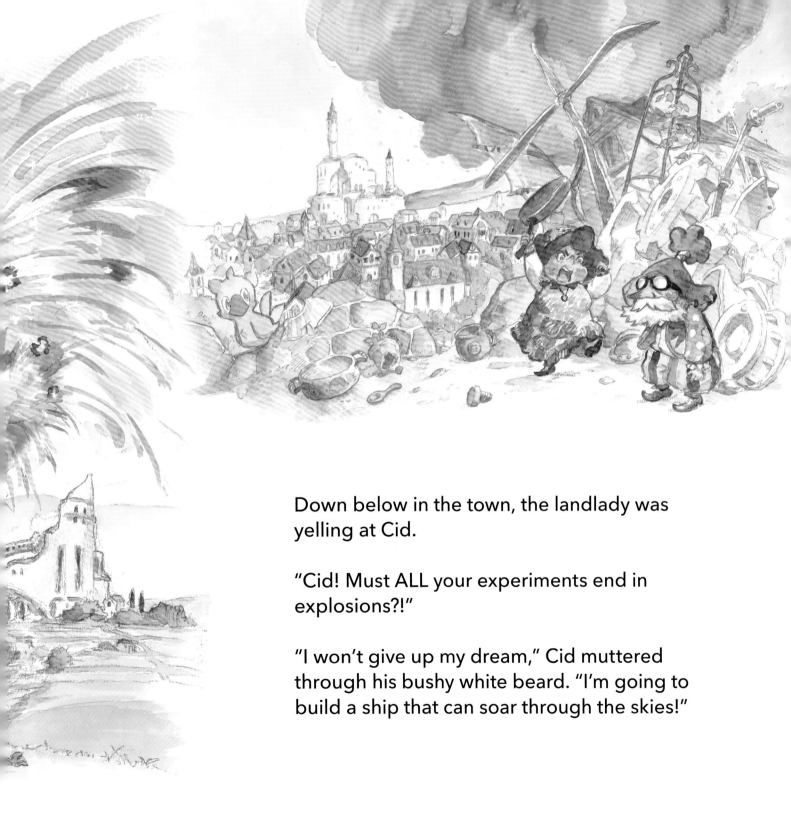

Down below in the town, the landlady was yelling at Cid.

"Cid! Must ALL your experiments end in explosions?!"

"I won't give up my dream," Cid muttered through his bushy white beard. "I'm going to build a ship that can soar through the skies!"

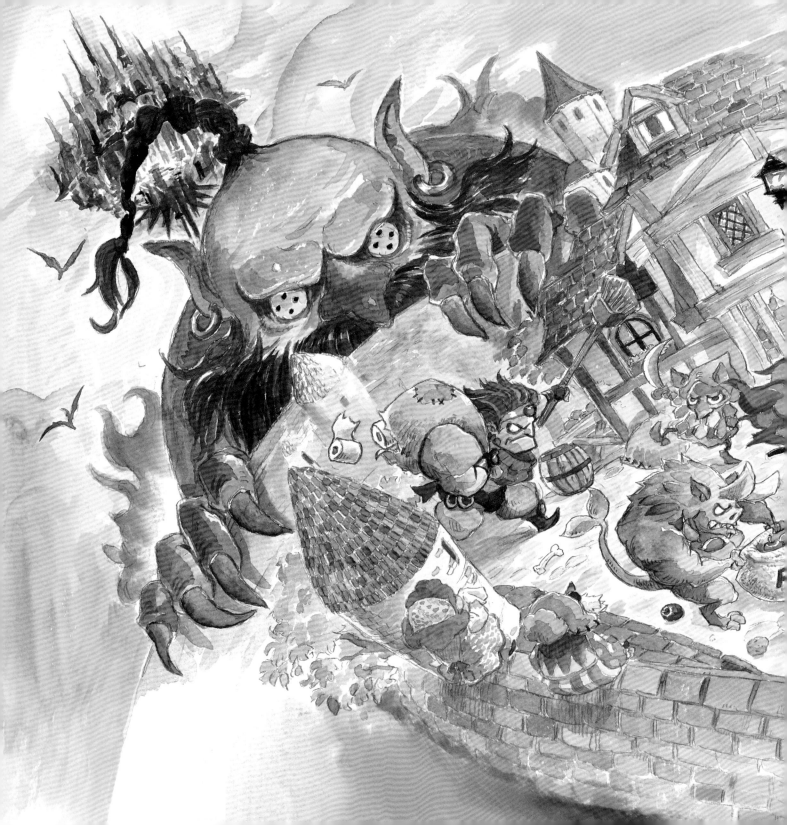

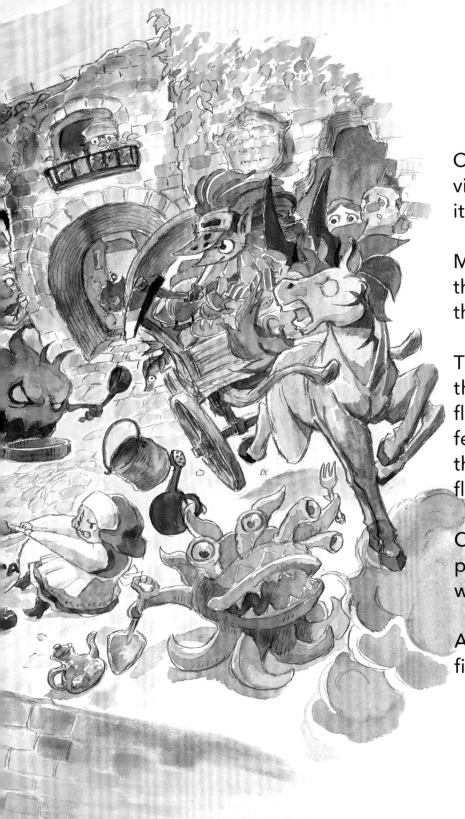

Cid's home had once been a vibrant and bustling town. Now it was almost empty of people.

Monsters ran pell-mell through the streets, stealing everything they could find.

The boss of the monsters was the Djinn, a fiendish spirit of flame. He had been sending his fearsome flunkies to terrorize the town from high atop his flying fortress in the sky.

Cid and the rest of the towns-people were at their wits' end, with no way to stop the beasts.

At least not until Cid could finish building his airship!

Little Chocobo made up his mind to help Cid.

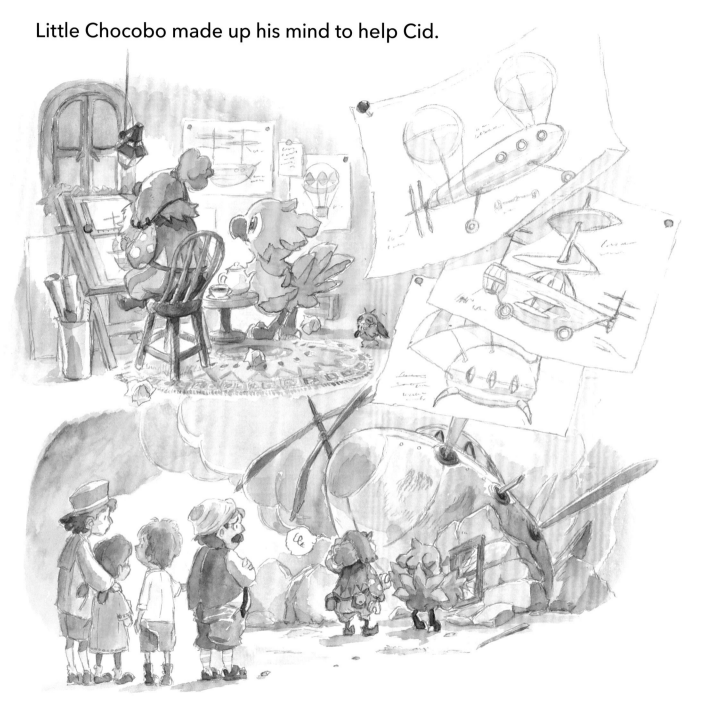

They worked hard together, but their efforts failed again and again, often foundering in more fireworks. Still, Cid refused to give up!

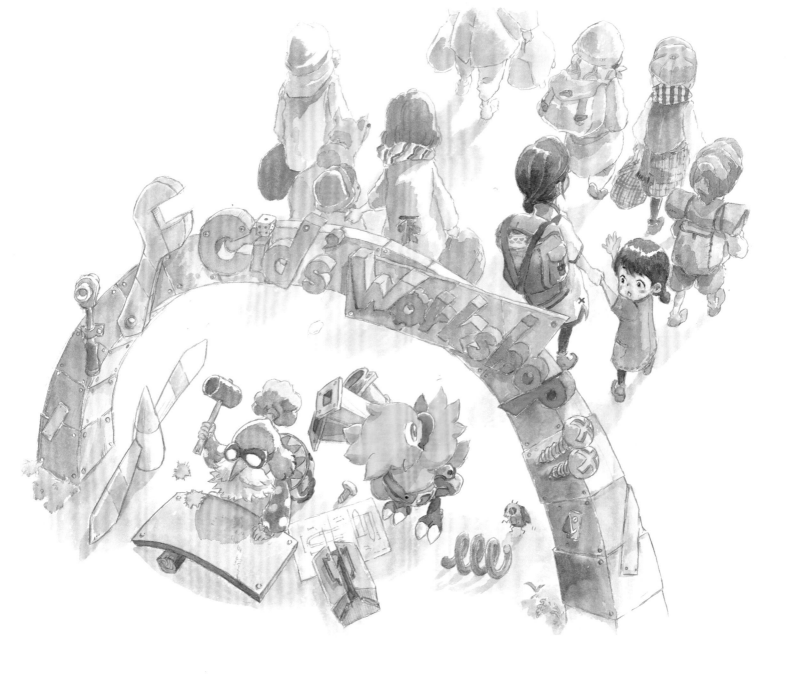

Through all their mistakes, Cid was gaining glimmers of hope. But with each failure, the people still living in the town were losing heart. One by one they started to leave.

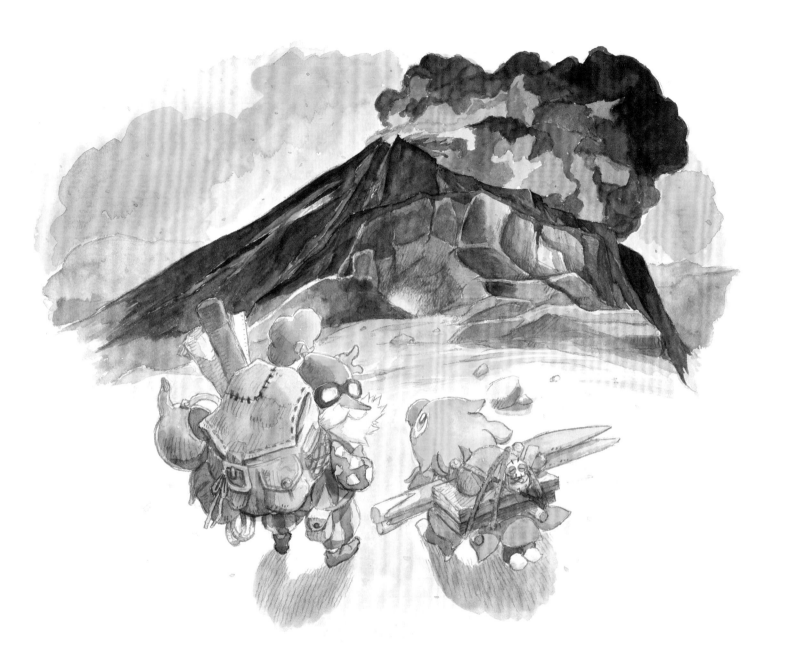

Cid and Chocobo decided to spare the landlady's house any more untimely explosions. So they packed up and moved their workshop to a cave under the side of a great volcano west of town.

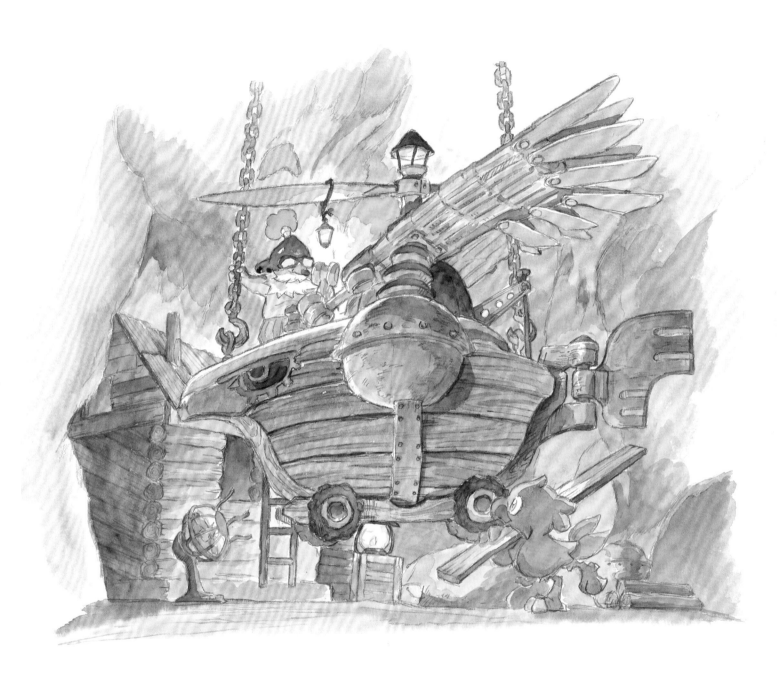

Together they toiled and sweated and strove,
until their airship was nearly finished.

There was only one problem left…but it was a big one! How could they give the ship enough power to fly?

Then one day, a book in one of the teetering piles on the workshop floor caught Cid's eye.

"That's it!" he cried out. "Eureka!

"Chocobo, look! It says here there's a stone that can make our ship fly!"

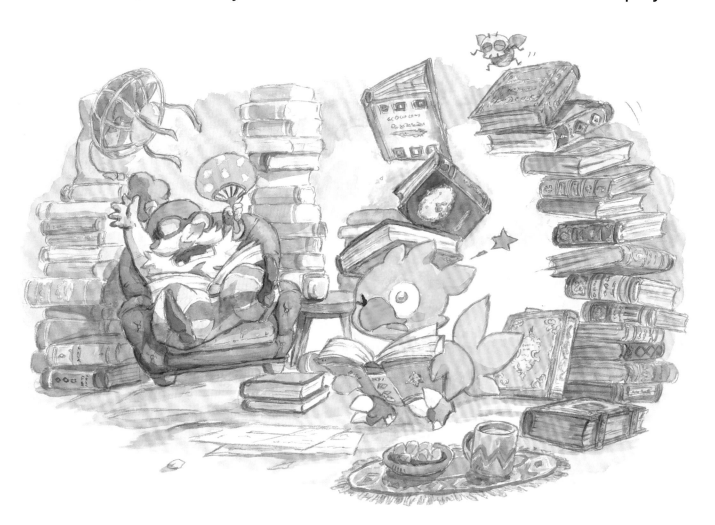

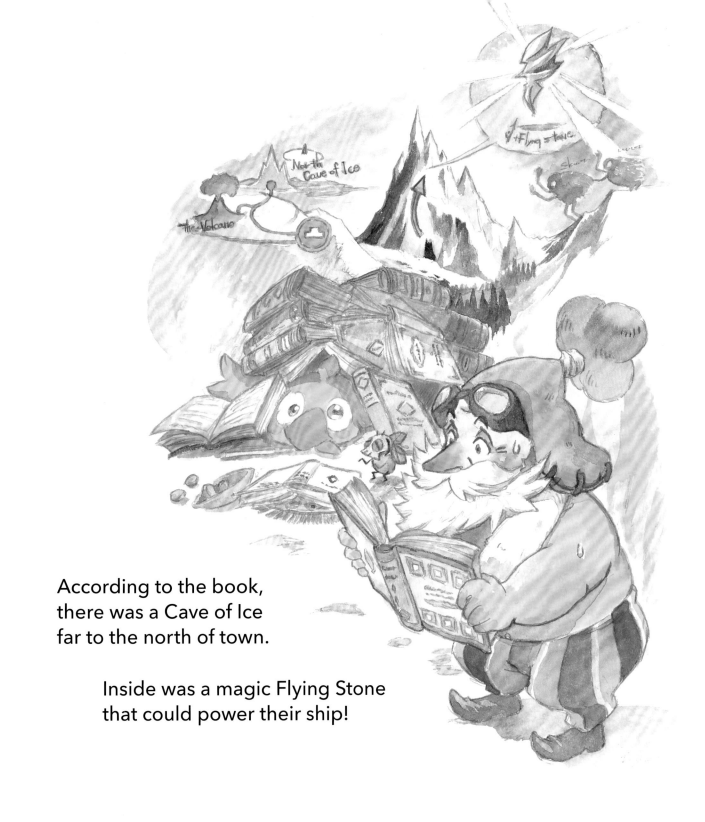

According to the book,
there was a Cave of Ice
far to the north of town.

Inside was a magic Flying Stone
that could power their ship!

There was no time to waste,
so the pair rushed off to find the Cave of Ice!

They crossed rolling fields and great mountains,
until at last they found it.

"Looks nice and warm,
gwok gwok!"

"Kweh kweh!"

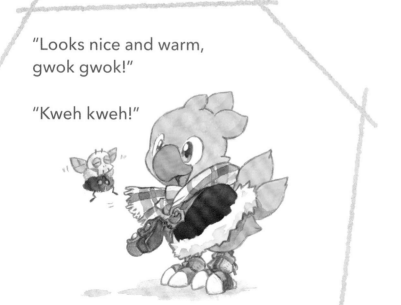

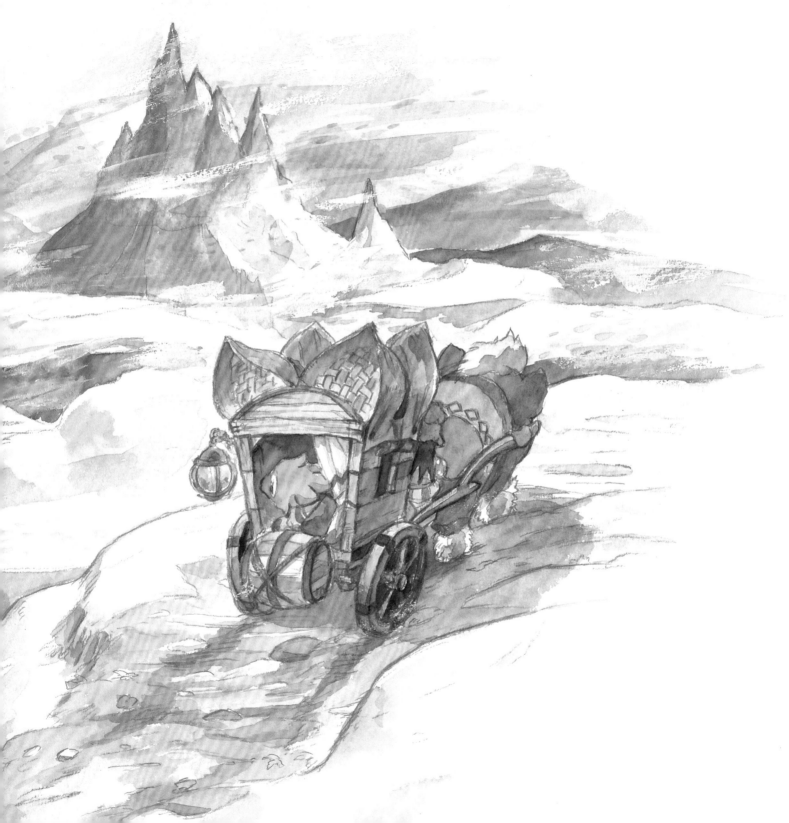

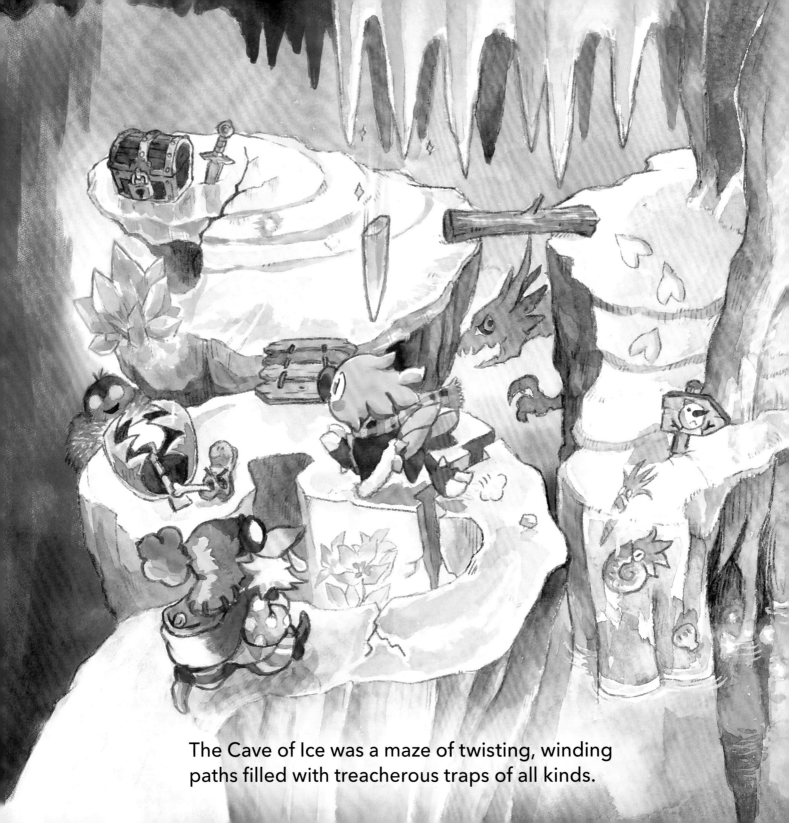

The Cave of Ice was a maze of twisting, winding paths filled with treacherous traps of all kinds.

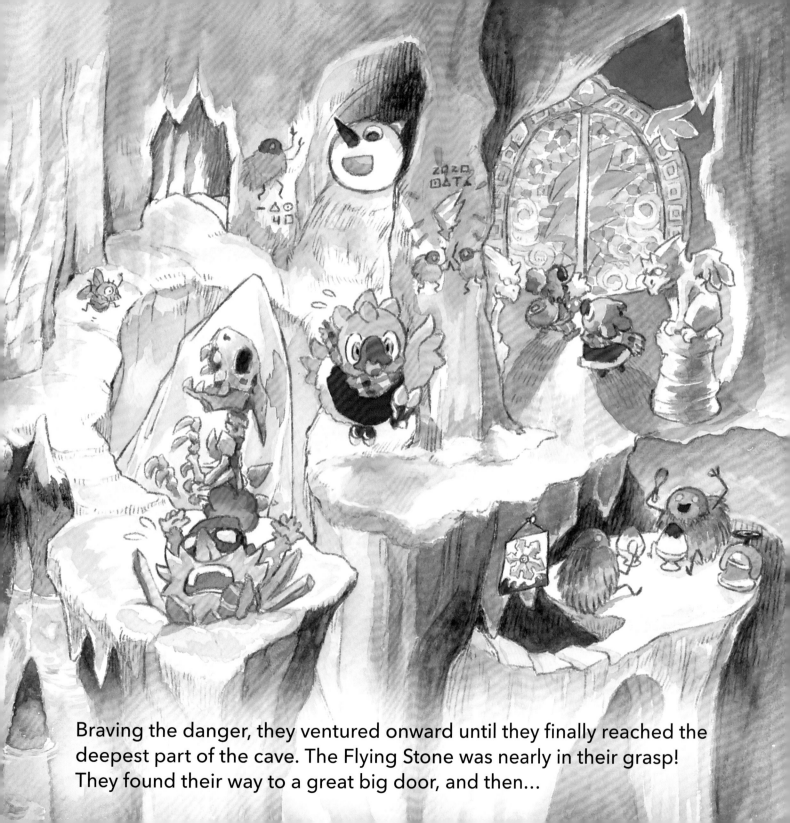

Braving the danger, they ventured onward until they finally reached the deepest part of the cave. The Flying Stone was nearly in their grasp! They found their way to a great big door, and then...

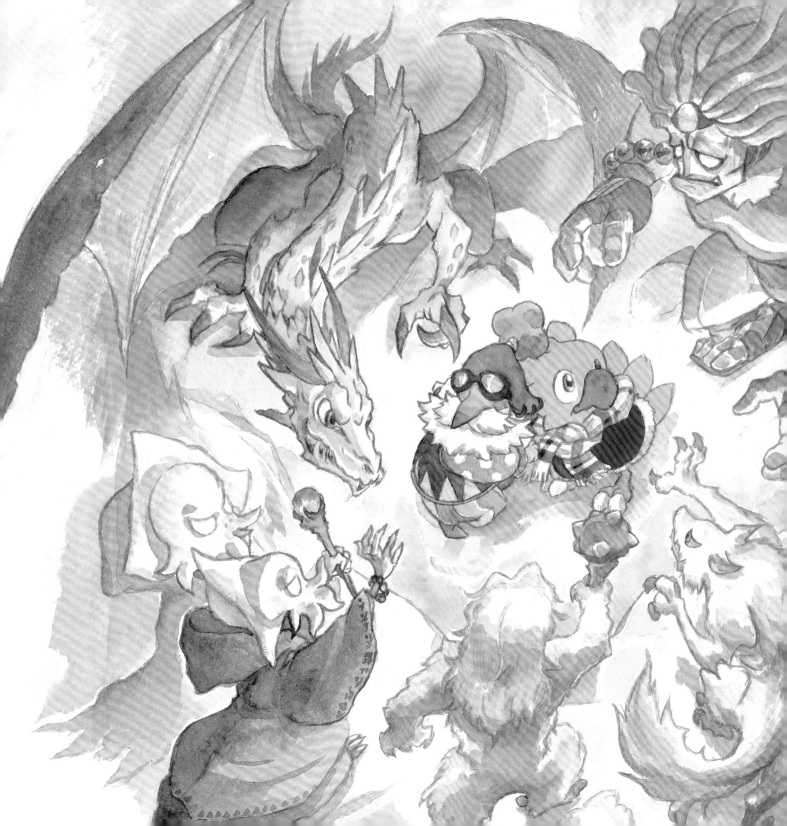

...they found themselves in a great big heap of trouble!
They were surrounded by a pack of frightful monsters!

# HOW WOULD THEY EVER ESCAPE?

# "STOP RIGHT THERE, FIENDS!"

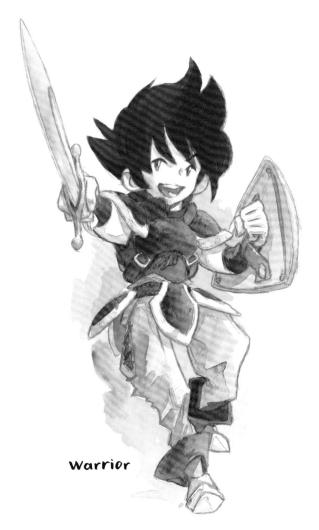

Warrior

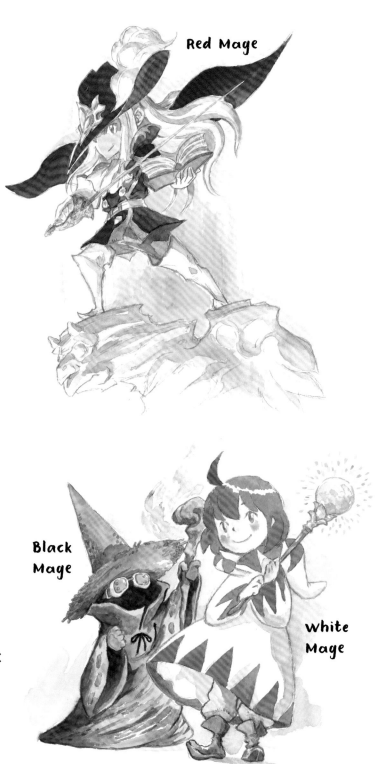

Red Mage

Black Mage

White Mage

Just in the nick of time, four heroic adventurers arrived: Warrior, Red Mage, Black Mage, and White Mage!

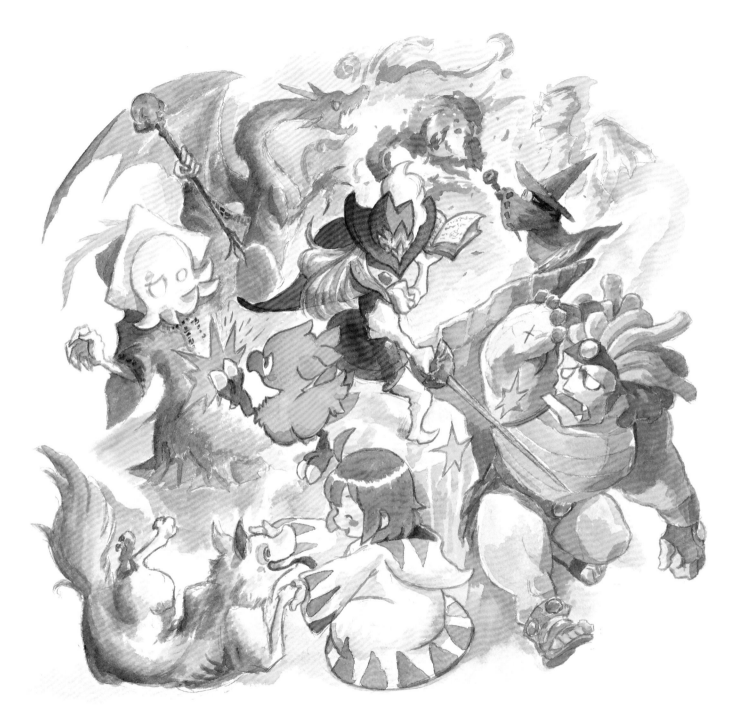

These brave souls had come to the rescue! And with
Chocobo's help, they beat the monsters in a flash.

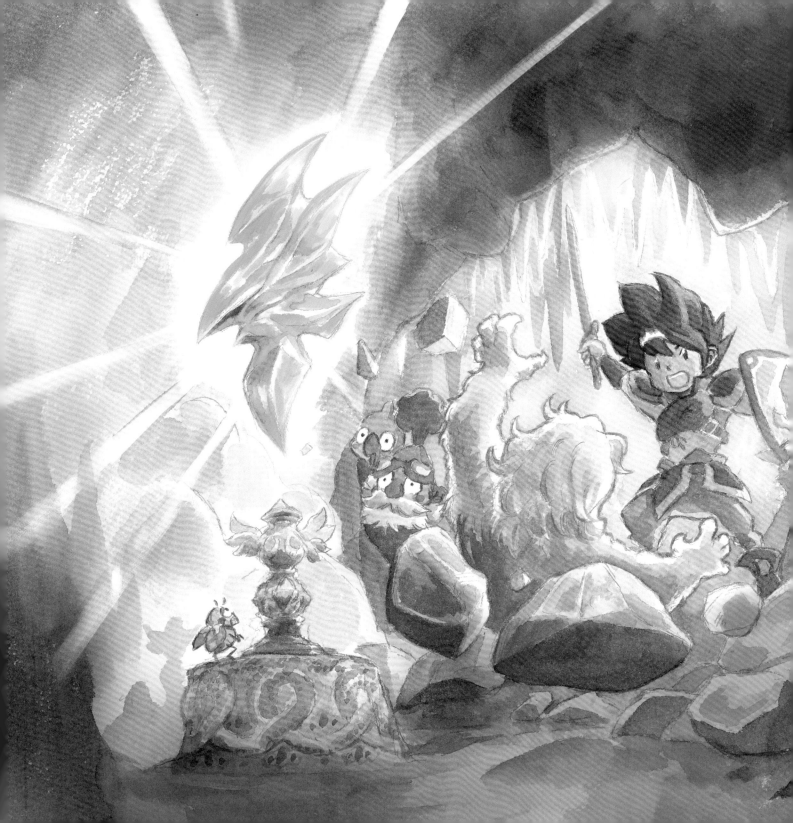

With the monsters defeated, the hidden chamber beyond opened. Inside, the Flying Stone floated, bobbing gently in the air.

"You did a great job, Chocobo," said Black Mage. "Here, these are for you." He placed a pair of stylish goggles on Chocobo's head.

"Now, let's get back to town!"

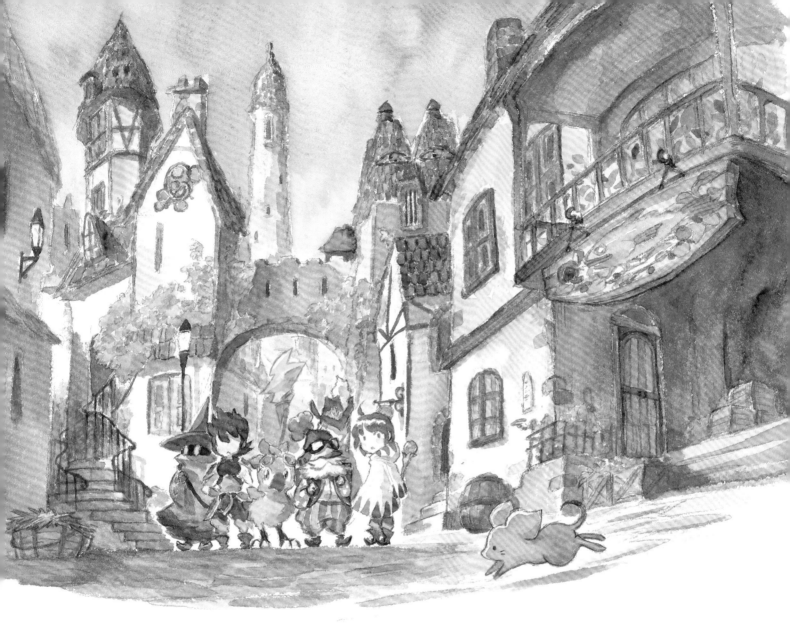

Chocobo and his friends returned to the town, but sadly, it was still empty.

"I guess the people aren't coming back..." said Cid.

Or so he thought!

"Cid! You got your hands on a Flying Stone, I see!"

The landlady had returned. And so had all the townspeople!

"Well, don't just stand there gawking! Get that flying boat of yours finished!"

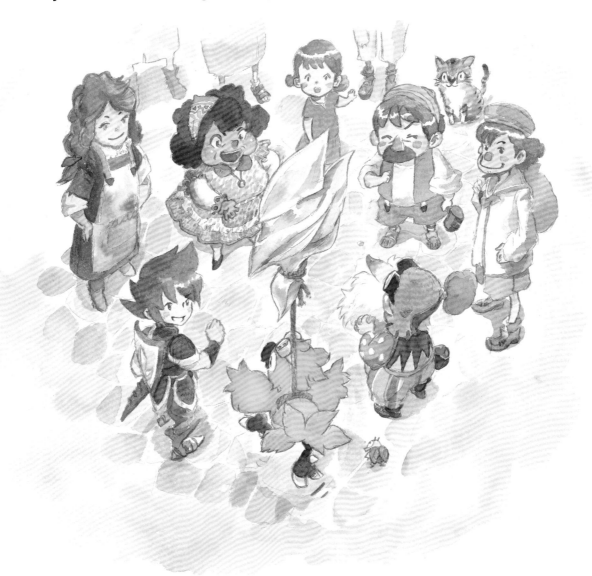

"We'll help too!" said the townspeople, as they came running to lend a hand.

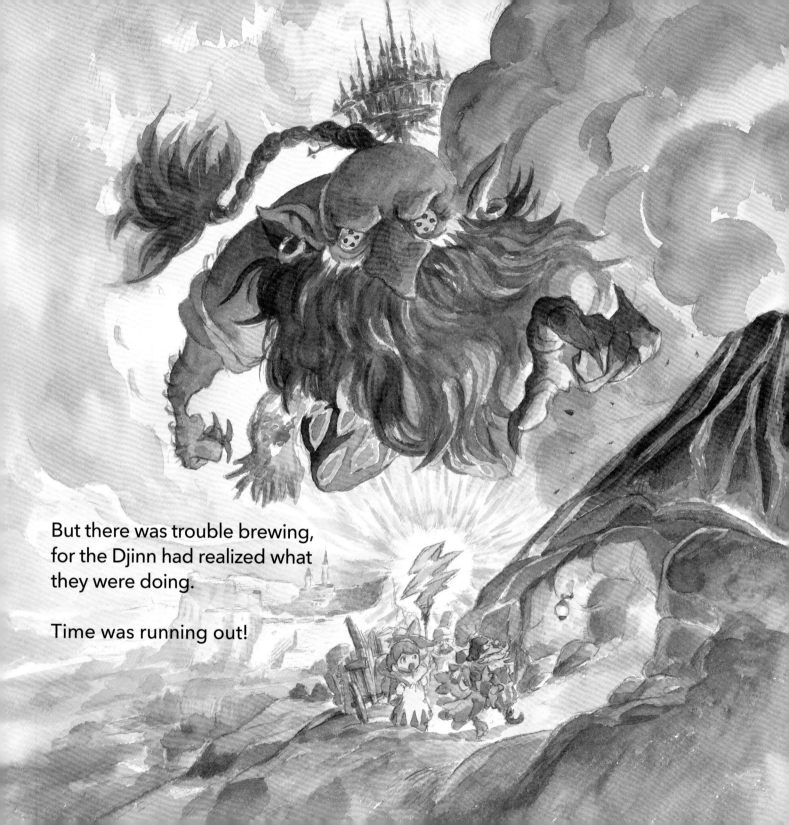

But there was trouble brewing, for the Djinn had realized what they were doing.

Time was running out!

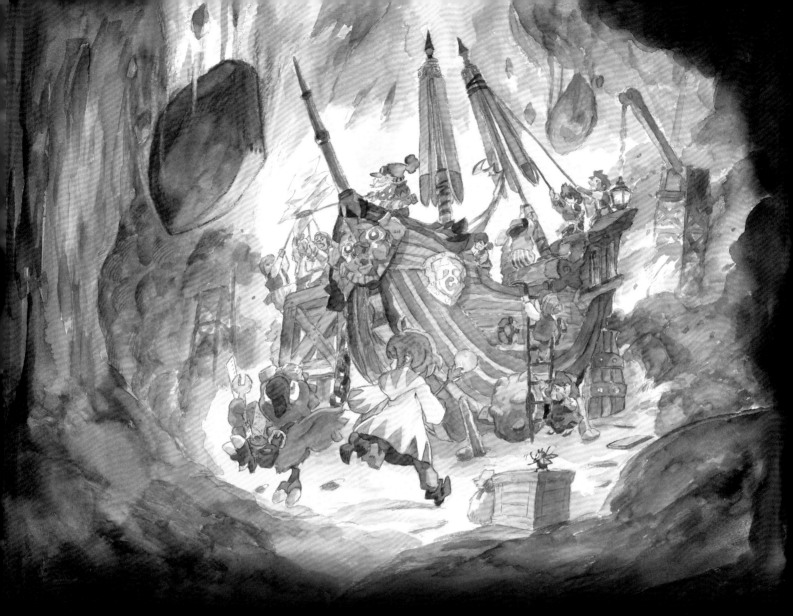

# RUMBLE RUMBLE RUUUMBLE!

The Djinn used his powers of fire to make the volcano erupt!

It didn't stop the townspeople, though. They believed with all their hearts that they could finish the ship, and not a one of them thought about running away.

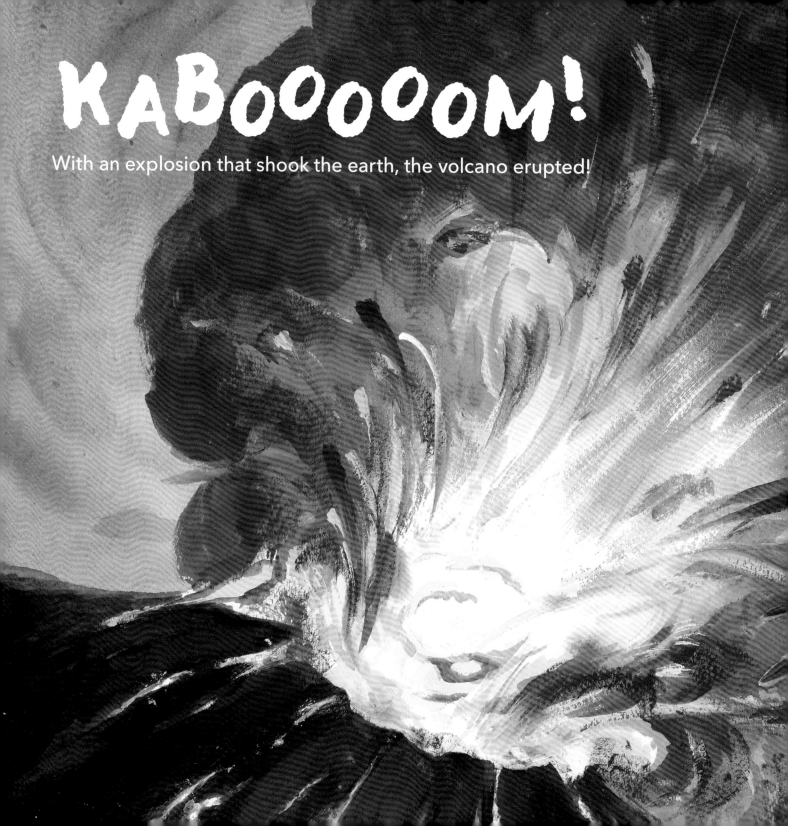

# KABOOOOOM!

With an explosion that shook the earth, the volcano erupted!

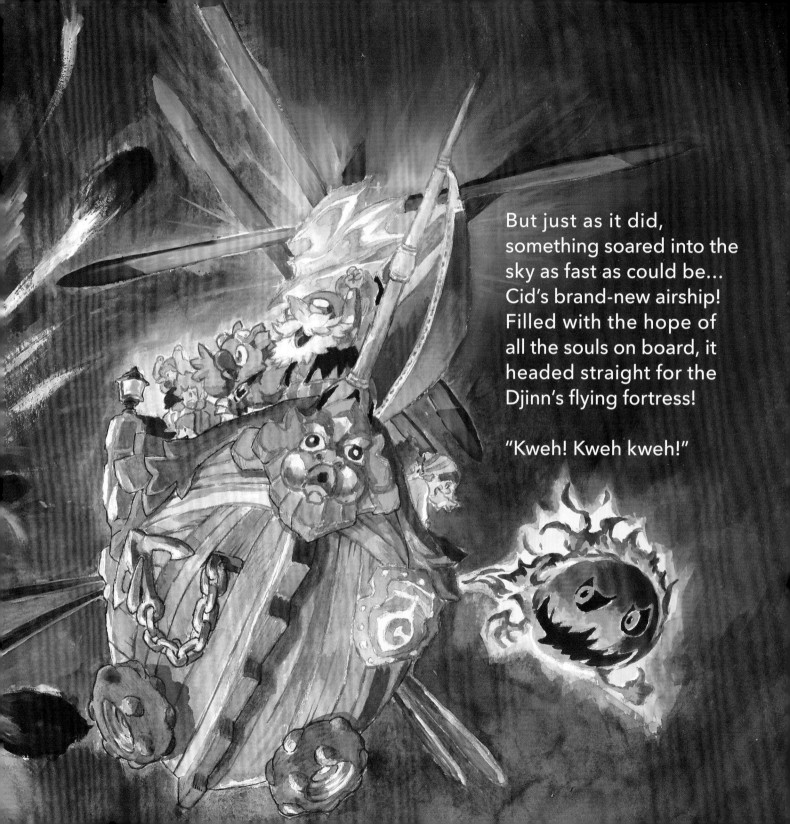

But just as it did, something soared into the sky as fast as could be... Cid's brand-new airship! Filled with the hope of all the souls on board, it headed straight for the Djinn's flying fortress!

"Kweh! Kweh kweh!"

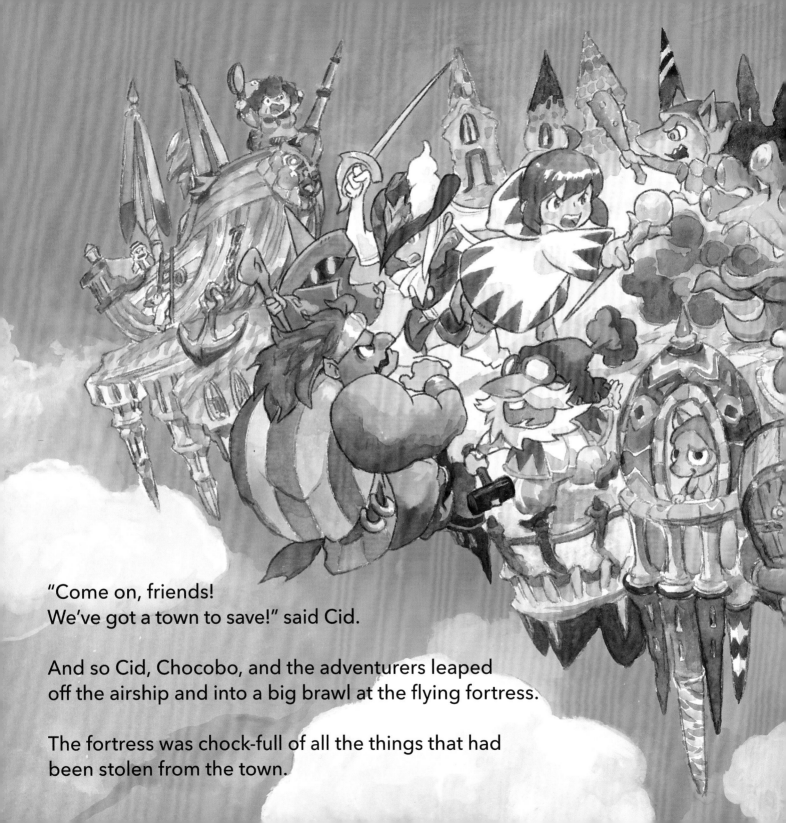

"Come on, friends!
We've got a town to save!" said Cid.

And so Cid, Chocobo, and the adventurers leaped
off the airship and into a big brawl at the flying fortress.

The fortress was chock-full of all the things that had
been stolen from the town.

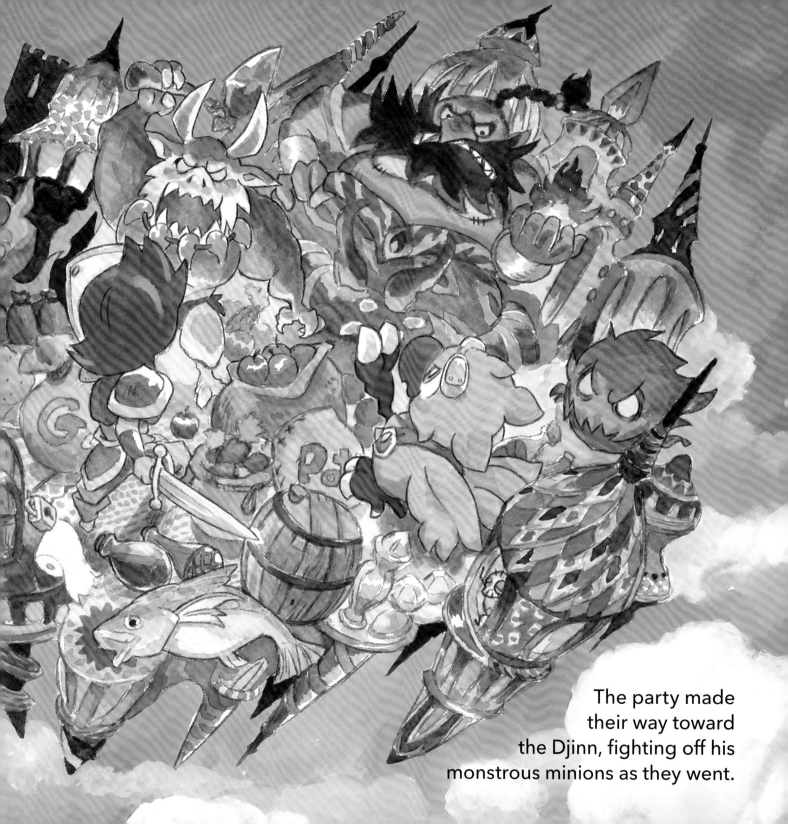

The party made their way toward the Djinn, fighting off his monstrous minions as they went.

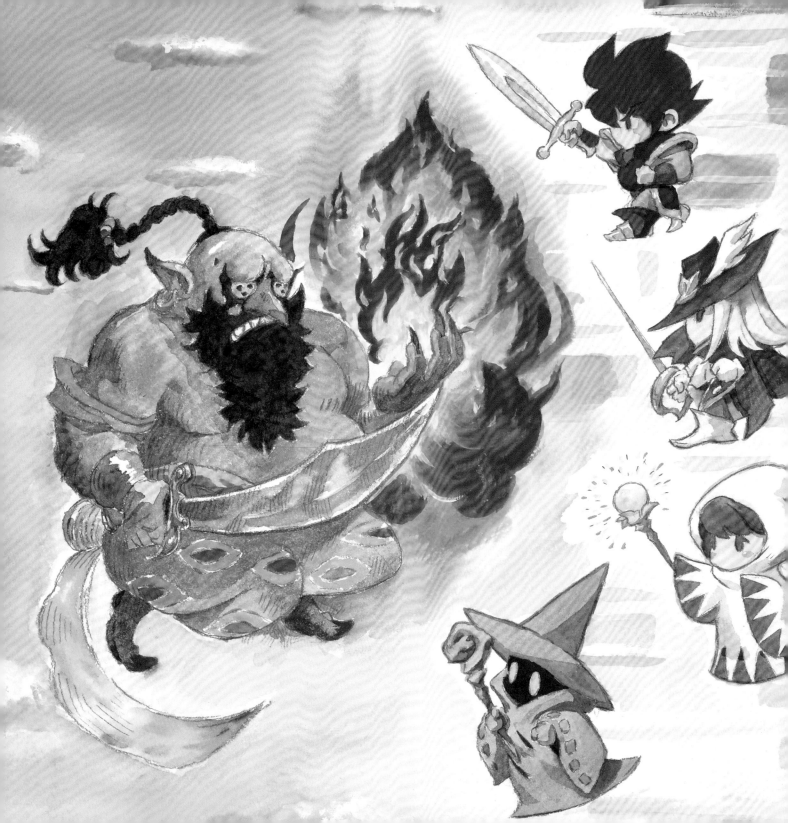

"I can't believe you made it all the way to my fortress! I, the great and powerful Djinn, underestimated that airship of yours!"

But Cid was quick to reply. "I never could have done it alone! My friends believed in my dream, and all of our hopes together are what made it fly! That's why we won't lose now, either!"

# AND SO THE SHOWDOWN BEGAN!

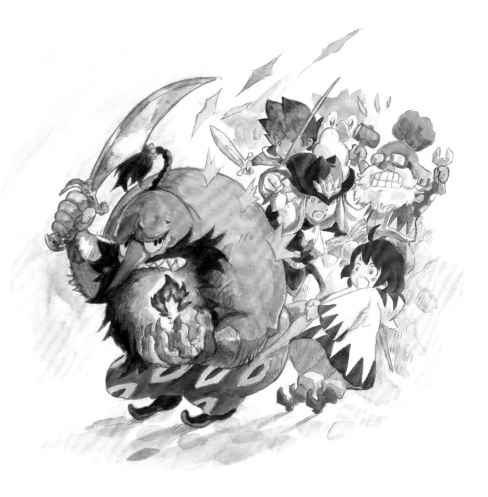

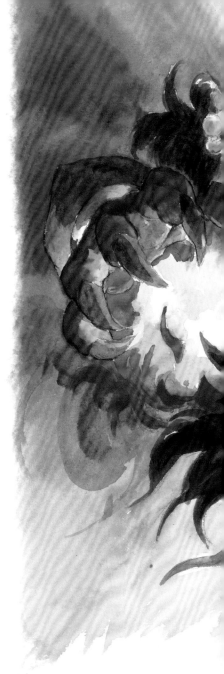

The adventurers attacked the Djinn all at once—
and so did Cid, with his trusty hammer!

Slowly but surely, they gained the upper hand,
and the Djinn found himself cornered.

"Drat! I'm in trouble now...

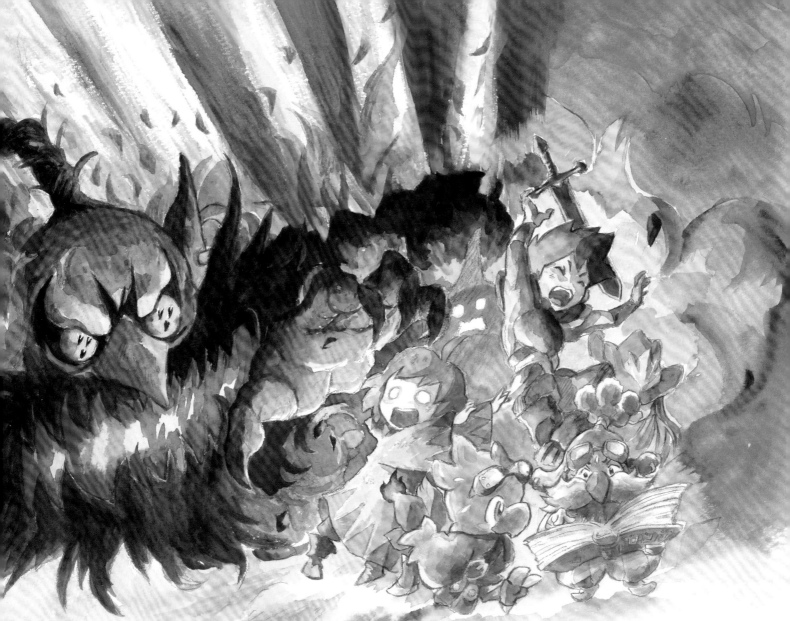

# "TIME TO HEAT THINGS UP! TAKE THIS!"

The Djinn cast a powerful Fire spell, and that spelled trouble for Chocobo and his friends!

"Chocobo! The book says he's weak to cold!" said Cid.

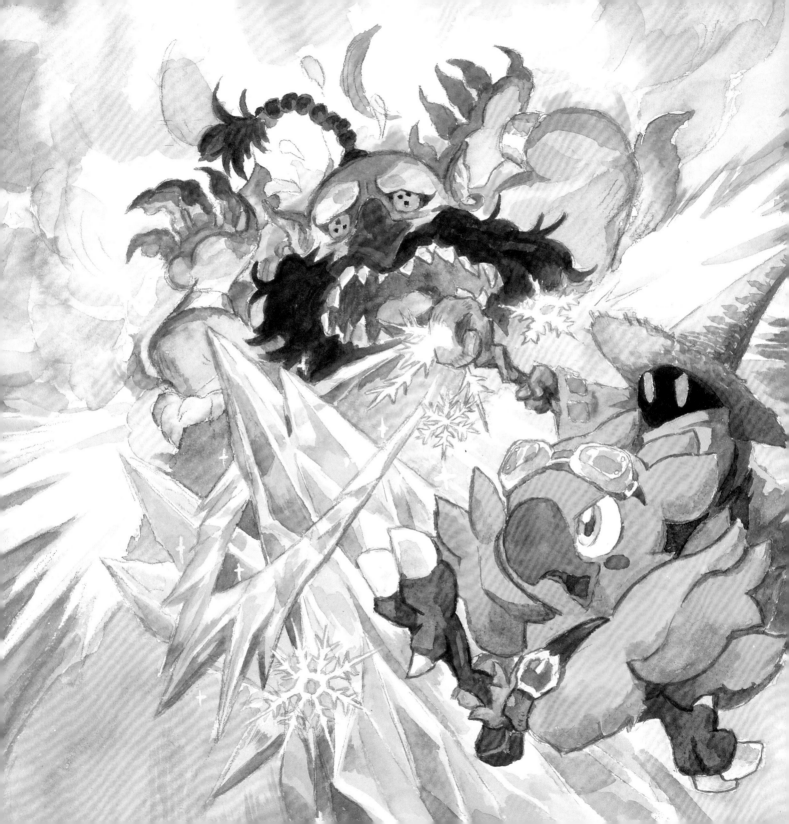

Hearing that, Black Mage shouted, "I'll cast ice magic at him! Once he's good and frosty, you do your thing, Chocobo!"

Black Mage quickly cast a Blizzard spell, which practically froze the Djinn solid! Without wasting a second, Chocobo unleashed a mighty Chocobo Kick!

THWACKITY THWACK THWACK!

And so the villainous Djinn, who had brought much misfortune to the town, was defeated.

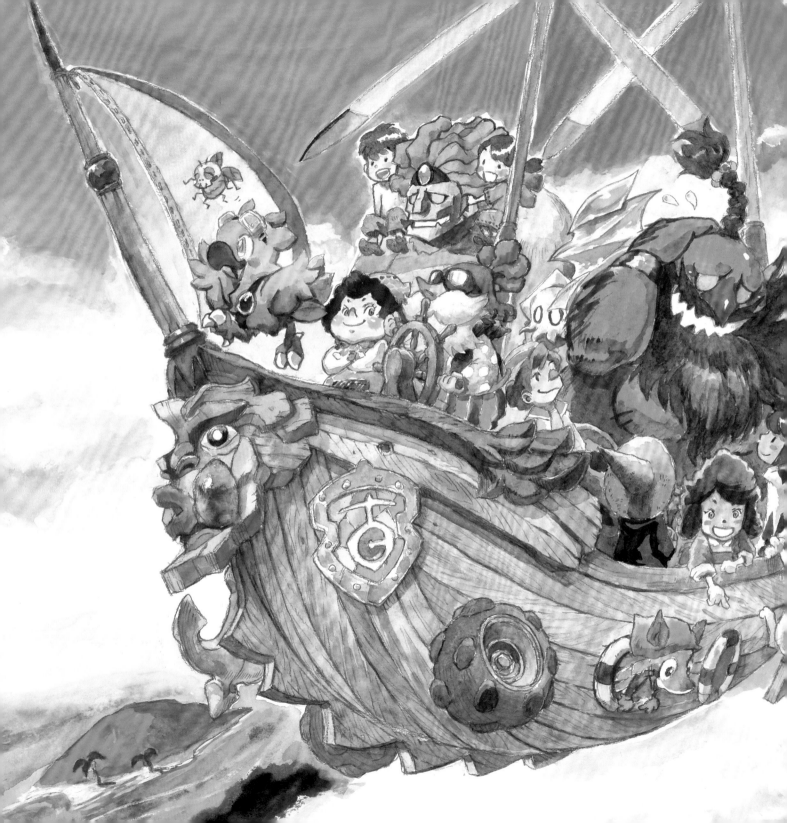

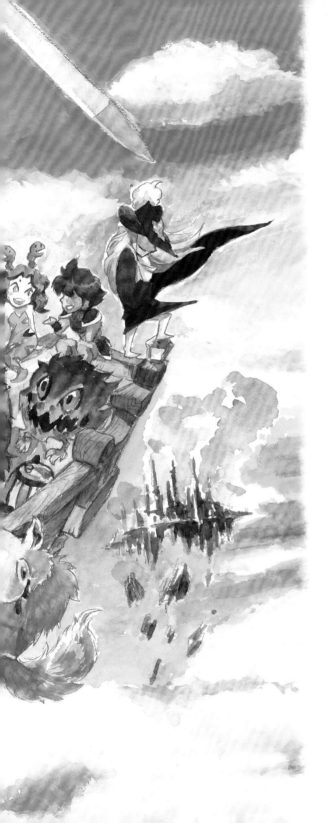

The flying fortress began to collapse, but Chocobo and his friends managed to escape back to the airship.

And they weren't alone—they took the Djinn and his monsters with them.

"I could tell they were sorry for what they did, so I brought them along," said Cid with a smile.

With the airship packed full of friends old and new, Cid set a course back to town!

Standing at the prow of the ship, Chocobo enjoyed the cool breeze on his feathered face as he gazed at the blue skies ahead.

He thought about his friends: Cid, who never gave up on his dream even when it looked hopeless, and all the wonderful townspeople who had helped out.

Each and every one of them had a special place in his heart.

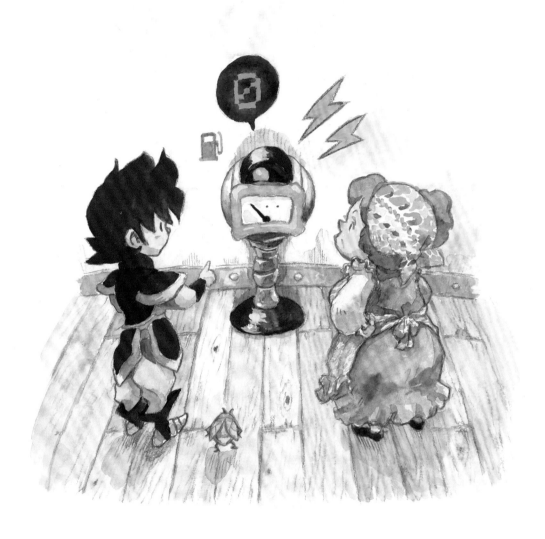

"Say, this red light here's been blinking for a while now.
What do you suppose it's for?"

"It shows how much fuel's left in the airship, I reckon.
But gosh…it looks like it's empty, huh?"

# AFTERWORDS & ABOUT THE CREATORS

## Writer:
## Kazuhiko Aoki
Square Enix Co., Ltd.

Kazuhiko Aoki has been involved in the development of many video game titles, including the mainline *Final Fantasy* series, *Chrono Trigger*, *Final Fantasy Crystal Chronicles*, the *Chocobo's Mystery Dungeon* series, and *Dragon Quest X Online*.

Years ago, I would look at the *Final Fantasy I* world map and try to turn the scenes that popped into my mind into stories.

I've written plenty of game stories since then, but I had no idea how to tackle writing a picture book. Ultimately, I started by writing the beginning and the end, and then worked out the rest from there. I think that might be the only way in which the process was similar to writing a video game. I'm truly grateful to all the staff and to the readers for giving me this rare opportunity. I think I'd like to try my hand at writing a light novel next.

## Illustrator:
## Toshiyuki Itahana
Square Enix Co., Ltd.

Toshiyuki Itahana creates character designs as a starting point for world-building in video games. His most notable works include the *Chocobo's Mystery Dungeon* series, *Final Fantasy IX*, and *Final Fantasy Crystal Chronicles*, among many others.

Chocobo has wings, but he can't fly. He's tiny but so strong with those Chocobo Kicks. He's a little bit timid but still loves adventure.

It's been about twenty-four years since I first designed this round little fellow, and I'm so delighted that I got the chance to jump out of the world of video games and try my hand at illustrating a new adventure in this picture book. I certainly owe the opportunity to all the fans who have loved Chocobo over the years—thank you all so much! I hope you'll continue to support him!

# CHOCOBO AND THE AIRSHIP
**A Final Fantasy Picture Book**

© 2021 SQUARE ENIX CO., LTD. All Rights Reserved.
First published in Japan in 2021 by SQUARE ENIX CO., LTD.
English translation © 2023 SQUARE ENIX CO., LTD.
All Rights Reserved. Published in the United States by
Square Enix Books, a division of SQUARE ENIX, INC.

ISBN: 978-1-64609-203-1

Library of Congress Cataloging in-Publication data is
available at https://lccn.loc.gov/2022035054.

Printed in China
First printing, March 2023
10 9 8 7 6 5 4 3 2 1

## SQUARE ENIX
### BOOKS
**square-enix-books.com**

999 N. Pacific Coast Highway, 3rd Floor
El Segundo, CA 90245, USA

## ENGLISH EDITION
Translator: Stephen Meyerink
Designer: Stephani Stilwell
Editor: Leyla Aker

## PLANNING & PRODUCTION
Square Enix Co., Ltd.
Editor in Chief: Kazuhiro Oya
Editors: Hiroyuki Ishii, Takuji Tada
Production: Toru Karasawa, Toshihiro Ohoka, Tsutomu Sakai

## STORY & WRITING
Square Enix Co., Ltd.
Kazuhiko Aoki

## JACKET, COVER & INTERIOR ART
Square Enix Co., Ltd.
Toshiyuki Itahana

## SUPPORT & SUPERVISION
Square Enix Co., Ltd.
Creative Business Unit II
Creative Division

## DESIGN
MiKEtto